A SHEPHERD'S LIFE

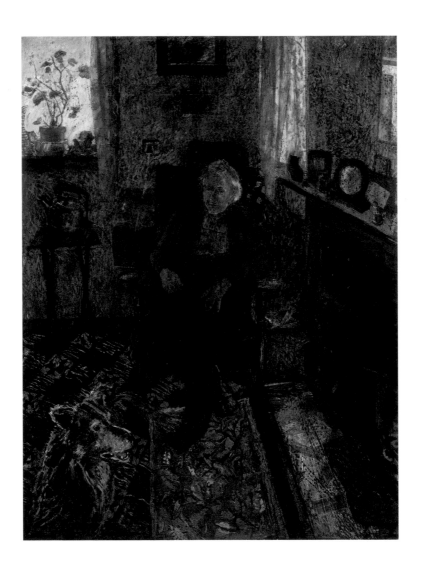

PAINTINGS OF JENNY ARMSTRONG
BY VICTORIA CROWE

A Shepherd's Life

Julie Lawson & Mary Taubman
Scottish National Portrait Gallery
Edinburgh

Published by the
Trustees of the National Galleries of Scotland
for the exhibition *A Shepherd's Life: Paintings of Jenny Armstrong by Victoria Crowe*
held at the Scottish National Portrait Gallery, Edinburgh
from 16 February to 28 May 2000.

Reprinted 2008 by the Trustees
of the National Galleries of Scotland in association with
the Trustees of the Fleming-Wyfold Art Foundation for the exhibition
A Shepherd's Life: Paintings of Jenny Armstrong by Victoria Crowe
held at The Fleming Collection, London,
from 13 January to 21 March 2009.

ISBN 1 903278 02 3
Designed and typeset in Golden Cockerel by Dalrymple
Printed and bound by Estudios Graficos Zure, Spain

Front cover: detail from *Large Tree Group*, 1975
Private collection

Frontispiece: *The Room in Autumn*, 1981
Collection of the artist

FOREWORD

In the year 2000, the Scottish National Portrait Gallery elected to celebrate the heroism of everyday life in Scotland in a series of exhibitions and publications, of which *A Shepherd's Life* was the first.

A Shepherd's Life focuses on a series of paintings and drawings, by the distinguished artist Victoria Crowe, depicting the shepherd, Jenny Armstrong. Jenny Armstrong was born in 1903 at the farm of Fairliehope, near the village of Carlops and worked all her life in the lower Pentland Hills. Victoria Crowe's pictures pay tribute to the life and work of this individual and at the same time record a rural way of life, once common, but now changing so fast that it has evolved beyond recognition.

The original exhibition in 2000 at the Scottish National Portrait Gallery yielded surprising results. It attracted not just the usual gallery going public but also people from farming and rural communities, those interested in memory, reminiscence and positive images of old age, as well as educational groups. So while Victoria Crowe was telling one person's story, in the paintings, the result is in a very real sense a part of everyone's story, dealing as it does with issues of working, ageing, love and loss.

We wish to extend our thanks to all the collectors who have permitted these works to be shown together again and we are grateful to The Scottish Gallery, Edinburgh and The Thackeray Gallery, London for their assistance in tracing paintings and for corresponding with lenders. We wish to thank Mary Taubman who proposed and devised the exhibition and we would also like to thank the staff of the National Galleries of Scotland who have been involved with this project, in particular Julie Lawson.

We are very pleased that through Selina Skipwith, at The Fleming Collection, the exhibition has now been brought to London.

John Leighton *Director-General*
National Galleries of Scotland

James Holloway *Director*
Scottish National Portrait Gallery

THE FLEMING-WYFOLD
ART FOUNDATION

The Trustees of The Fleming-Wyfold Art Foundation have reprinted this book in association with the Trustees of the National Galleries of Scotland in the knowledge that the story it tells will be an inspiration to many.

The Fleming-Wyfold Art Foundation through exhibitions like *A Shepherd's Life* is dedicated to raising the profile of Scottish art, which is poorly represented in museums and galleries outside Scotland. The foundation was established as a charity in 2000 to look after The Fleming Collection of Scottish art and to maintain a gallery in London showing paintings from the collection and other public and private galleries.

We wish to thank the staff of the National Galleries of Scotland, namely James Holloway and Julie Lawson for working with us in bringing this exhibition to a London audience. We would also like to thank the staff of The Fleming Collection who have been involved with this project, in particular Briony Anderson. We offer our gratitude to Victoria Crowe for giving her time and sharing her insights so generously and to Mike Walton for his support throughout and to all the lenders for making the exhibition possible.

INTRODUCTION

JULIE LAWSON

WHEN VICTORIA CROWE CAME TO LIVE IN KITTLEYKNOWE in the Pentlands in 1970, she had – perhaps unwittingly – entered the territory of *The Gentle Shepherd*. The poet, Allan Ramsay (*c.*1685–1758), had written and set his pastoral verse drama of that name in the area, some sixteen miles south of Edinburgh. Ramsay believed that the Scottish vernacular, whose survival was inextricably linked with the traditional rustic way of life which he celebrated in the work, represented a pure, uncorrupted form of the Scots language. This was a view shared by others, including the poets Robert Fergusson (1750–1774) and Robert Burns (1759–1796).

In a series of paintings made over twenty years, and based on close observation, Victoria Crowe has portrayed the landscape and the activity within it of an individual shepherd – Jenny Armstrong. In doing so, she has also depicted a place and way of life that two hundred years earlier had been seen as emblematic of the 'real' Scotland, a place where the shepherd embodied the authentic Scot. This body of work celebrates a particular life. At the same time, it describes an ancient way of living that has been long in decline

and which, at the beginning of the twenty-first century, may be finally disappearing.

Artists who explore the theme of a shepherd's life and landscape could be seen to relate to a tradition that has itself been a constant in Western art and thought. To contemplate the shepherd is to reflect upon a person and a way of life left behind by progress or change. The tending of sheep in its slow rhythms is a scene to console and reassure us when society is rapidly changing. The 'Pastoral', from Virgil and Ovid to Handel and Wordsworth, is the genre that has provided artists with the means of contemplating the mythical origins of society, the development of civilisation, and the relationship of man to nature. In the 'ideal', Italianate Arcadian landscape, exemplified by the paintings of Claude (1604–1682), the shepherd represents the innocence of our early human condition, living a life of contented – if limited – rustic simplicity, tending his sheep in an essentially benign nature. This image was transformed, but not forgotten, in the nineteenth century by painters like Jean-François Millet (1814–1875). He depicted workers on the land in a way that gave the repetitive and physically exhausting tasks they perform the significance of a religious ritual. The shepherd was transformed from exemplar of innocence to that of tenacity and stoicism in nature conceived as a place of moral challenge. Millet's paintings of the French peasantry are symbolically potent statements about the cycles of nature, life, death and regeneration. He depicts the Christian shepherd, the shepherd of wild places, tending flocks in the

harsher reality beyond the Alps. It is not a huge imaginative journey from Millet's France to twentieth-century Scotland, whose terrain is also often cold and inhospitable.

Victoria Crowe occasionally echoes the archetypal Millet compositions of scenes of agricultural workers – *The Sower* and *The Gleaners* – in her depictions of Jenny Armstrong. For example, in, *Sheep, Shepherdess and Harbour Craig* (p.29) the outstretched arm of the silhouetted figure, the other arm clutching a bag of feed, is reminiscent of the former. There is a compositional echo of the latter in the high horizon upon which, instead of a hazy outline of a haycart, there stands a ruined building. The desired effect is, as with Millet, a sense of the permanence, invariability, inevitability of these necessary

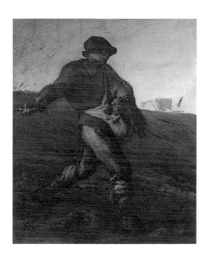 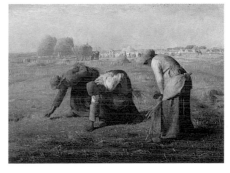

Jean-François Millet 1814–1875

left: *The Sower*, Museum of Fine Arts, Boston

above: *The Gleaners*, Musée d'Orsay, Paris

human activities. The inclusion of a distant ruin, placed centrally and therefore prominently on the horizon, while it may be an actual feature in the landscape, serves much the same purpose as a ruin placed in an 'ideal' landscape: to set up thoughts about the timelessness of the shepherd's tasks. By implication, human life, when thought of as a cycle to be repeated, can outlast edifices and empires. The snow, however, transposes the Arcadian theme to an uncompromisingly northern clime.

When Crowe came to depict the landscape that was the setting for Jenny Armstrong's work as a shepherd, she echoed those northern painters who have endowed the reality of the landscape that they depicted with a symbolic resonance. While the colours often recall the glowing, golden-browns of Millet's palette, the grey cast of snow and skies bring to mind the great German Romantic painter of the theme of man and nature – Caspar David Friedrich (1774–1840). In the painting *Large Tree Group* (p.27), the silhouette of the skeletal tree, placed on the axis of the painting and huge in scale, dwarfs the figure of the shepherd who is stoically walking through the snow – like a pilgrim making the arduous journey towards a mighty cathedral. It is reminiscent of paintings by Friedrich in which there is an actual Gothic cathedral – its spires representing for him hope and eternity – the figure, the soul's pilgrimage. Victoria Crowe's vision is, however, a secular one devoid of any such overtly religious symbolism. She includes no 'otherworldly' religious references, but rather she

reminds us of the rituals of nature; processes that have their own justification and, in turn, justify the lives of those who respect and reconcile themselves to their inevitability. Crowe's paintings are also, importantly, about the artist and her response to the surroundings.

Announcing the shepherd's presence as an inhabitant, as opposed to a migrant worker, an unaccommodated person in the landscape, is her cottage. In the painting, *Snowbound Cottages* (p.22), in which we see two cottages across a field of snow, we are on the outside, looking across to the place of safety – the destination after traversing the cold, hard terrain. The orange lights in the windows – warm notes in the prevailing greyness – intimate the settled life of Jenny Armstrong.

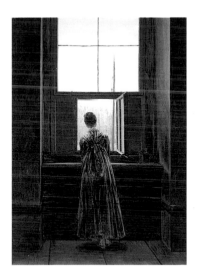 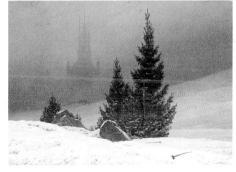

Caspar David Friedrich 1774–1840

left: *Woman at a Window*
Staatliche Museen zu Berlin Preußisher
Kulturbesitz, Nationalgalerie

above: *Winter Landscape*, National Gallery, London

Light shining out of the window designates a place of rest and protection from the elements and from the night, and mitigates the vague sense of menace occasioned by the lowering, purple sky.

Having seen the shepherd as a distant figure in the landscape, we will come to see Jenny Armstrong from closer at hand. Eventually the interior of her cottage becomes the artist's object of fascination. Crowe's subject-matter is the place of the shepherd's dwelling and of her work, and the paintings fall into distinct groups – outdoor and indoor paintings. She finds a way of making paintings that will combine and fuse the two, so that eventually her work focuses more and more on the room in which Jenny Armstrong lived, and the contents of it, in a way that does not exclude the all-important outdoors. The key element in this is the window. We are always aware of the presence of the landscape beyond the cottage because of the light from the window – a now constant motif in the paintings of the room. Again, Crowe calls to mind painters like Friedrich who made the motif of a woman in a room with a window – at once so ordinary and seemingly insignificant – into one of the most haunting images in Western art. In Friedrich's painting, we observe the woman from behind – so we are the unseen observers and/or she is our proxy – looking out from the quiet interior onto the world. Friedrich was able to make such a simple motif capable of suggesting a complex range of human aspirations. It is in the sensibility of painters like Friedrich, Vermeer (1632–1675) and Chardin (1699–1779) that Crowe finds her

kindred spirits. What they have in common is that, as close observers of a particular corner of the world, they have looked with affection at the ordinary and the everyday and transformed it into paintings that have the capability to speak to us directly and to move us. We may think of Vermeer's lace-maker, or his maid pouring milk, or of one of Chardin's servant-girls. All of these painters remind us of the quiet, unsung heroism of everyday life.

One painting by Victoria Crowe may be seen as transitional between the outdoor and indoor works (p.30). We look through the window and see Jenny Armstrong setting off to go about her work in the fields. We know from the cards strung up in the room that it is Christmas time, but for the shepherd it is a day like any other: a 'day off' is an urban luxury. We regard the pictures of robins and Christmas trees, the Christ child with his mother; we think of the three wise men, and of course, the shepherds.

The framing device of doorways or windows is one used to great effect in paintings by Vermeer and Chardin. Crowe's windows and mirrors become pictures within pictures containing frames within frames. A painting in which she first explores this idea, *Range and Semmit* (p.45), also contains two key compositional ideas that were to recur and develop into later stylistic hallmarks. This is based on the arrangement of a series of objects, apparently arbitrarily brought together, having nothing in common except the person to whom they belong. They have significance for someone who is physically absent

19

from the picture, and so are endowed with secret meaning, clues about the person who has gathered them together. Then there is the dividing-up of the picture plane, the compartmentalising of elements. The fireplace provides a frame – a dark square of space in which, again, arbitrarily combined objects seem to float, unconnected: the glowing logs of the fire, the silky intimate article of clothing – feminine and perhaps at odds with the image of Jenny Armstrong we have been given. In the centre of the mantlepiece is the clock, literally transcribed but also, as in the time honoured still-life tradition, a *memento mori*, a reminder of time passing. Like the dying embers of a fire, the light will go out and these fragments will remain.

The idea of creating a portrait of a person who is not actually present in the painting is an idea that has a long tradition in still-life painting. We are often invited by a seventeenth-century Dutch still life to recreate imaginatively the person who has, so to speak, just left the room. This is the key idea in Crowe's last paintings about Jenny Armstrong. In the paintings of the room in which she lived, the objects contained within it – connected by memories – gradually gain a kind of talismanic quality for those who are left behind. After the death of her friend, the artist was working through the process of loss in these pictures – and in doing so discovered a means for the future. The proposition in such paintings is that if a portrait of a person can be made 'in absentia' – without the physical presence of the person – then something of the essence of that person has

somehow been distilled by the artist. The process of painting has worked a kind of alchemical redemption, and the past has in some real sense been regained.

In the still life with the paradoxical title, *The Future Remembered* (p.48) Victoria Crowe returns to the motif of the mantlepiece. It is a modern emblem picture. It is almost dreamed. There is an array of objects which refuse the idea of composition. In them, a whole life is suggested; clocks that tell different times, a calendar, a photograph of Jenny Amstrong's father, a box of face powder and a half-empty perfume bottle, suggestive of other possibilities, other paths she might have chosen. There are flowers that are alive now but will soon die, untasted fruit, a half-finished box of chocolates – a reminder that death is always an unmannerly interruption in the business of life. A mysterious figurine, with a finger to her lips, equally reminds us that there are always unlocked mysteries, undisclosed secrets. And finally, we see the reflection in the mirror. It is a window. Now, in this reflection, which is itself framed like a painting, indoors and outdoors are perfectly fused, have become one. And we see the sheep continue to feed in the landscape outside.

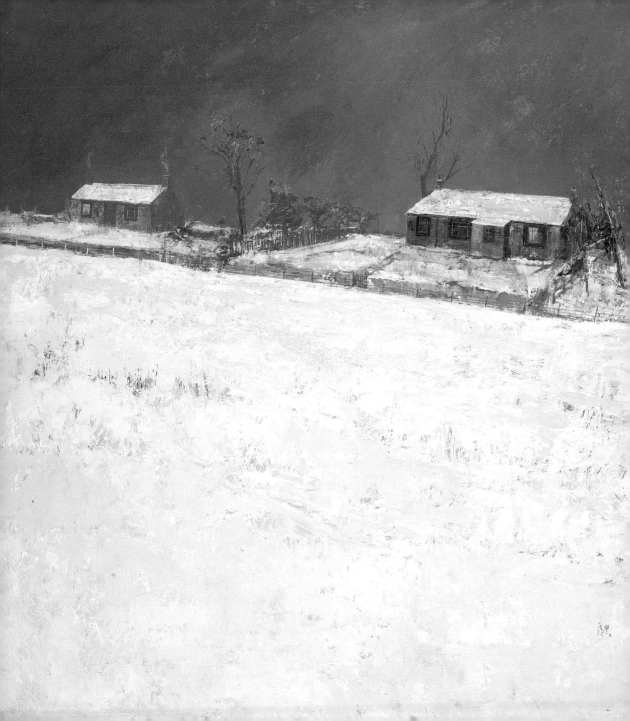

A Shepherd's Life

MARY TAUBMAN

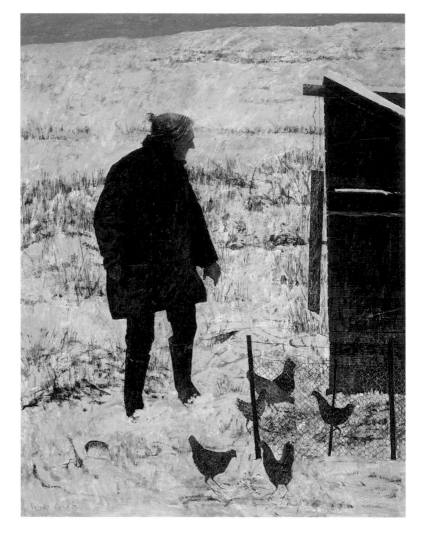

WE FIRST MEET JENNY ARMSTRONG in her mid-sixties and living in semi-retirement. The year is 1970. By this time her home has for many years been Monks Cottage, one of a small group of houses known as Kittleyknowe, which stands 1000 feet up on the road leading from Carlops to Auchencorth Moss. Monks Cottage, a two-roomed dwelling, gives access to enough open ground to accommodate various huts, sheds and hen-houses and to allow shelter and grazing for the occasional lambs, orphaned or abandoned by their mothers, which are passed to Jenny by local farmers to be nursed to health and then brought on for eventual sale at Lanark Livestock Mart.

Large-scale herding has now become for her a thing of the past, and at Monks Cottage she has settled down to a different, and mainly self-sufficient way of life. The hen-houses dispersed across her small domain are home to a flock of characterful Bantams and a group of chowy Rhode-Island Reds, all of them useful providers of food and entertainment. Vegetables are home-grown in a plot of ground adjacent to Monks Cottage and separated by a few trees and a straggling fence from the garden of a neighbouring dwelling, Monks View (p.22).

It is to Monks View that, in the autumn of 1970, Victoria Crowe and her husband Michael Walton come to set up house. Monks View will be their home for the next twenty years.

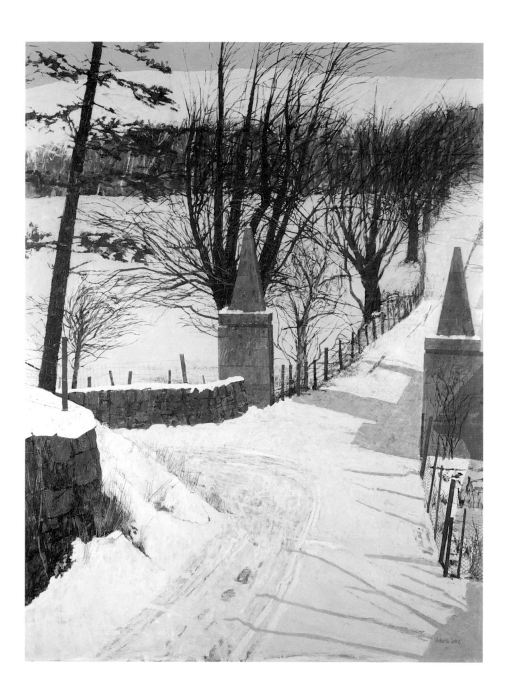

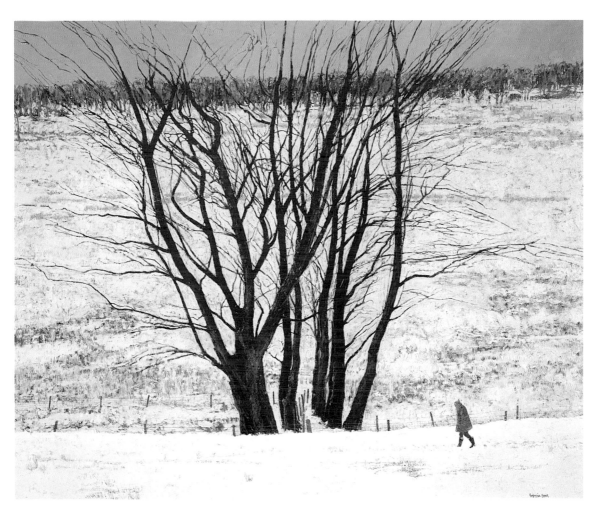

left:
Winter at Kittleybrig, 1974
Oil on board
121.9 × 91.4cm, 48 × 36in
Collection Tanya Westinghouse

above:
Large Tree Group, 1975
Oil on board
91.4 × 101.6cm, 36 × 40in
Private collection

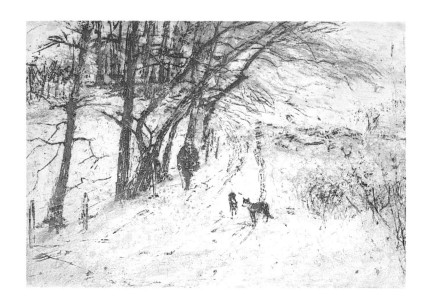

Landscape with Figure and Dogs
Etching and silk screen print
34.2 × 48.8cm, 13.5 × 19.2in
Graal Press and the artist

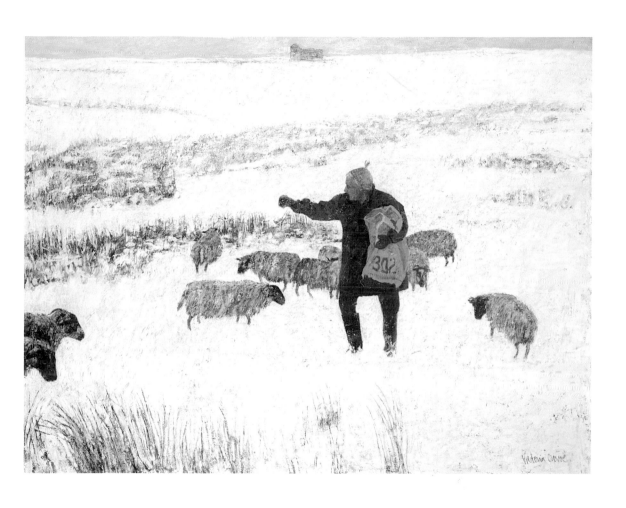

Sheep, Shepherdess and Harbour Craig, 1975
Oil on board
78.7 × 99cm, 31 × 39in
Private collection

December 25th, 1981
Oil on board, 91.4 × 71.1cm,
36 × 28in
Collection Tanya Westinghouse

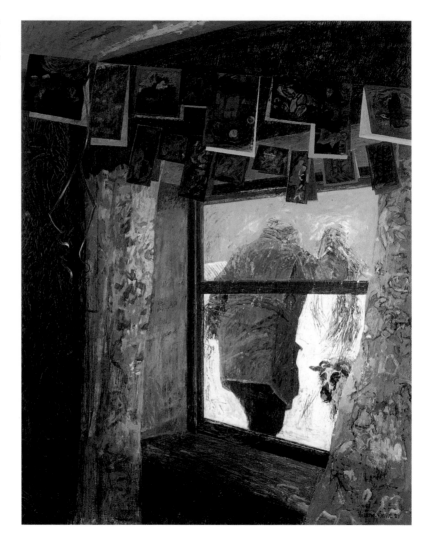

THE LANDSCAPE OF BROKEN MOORLAND and hills surrounding her home was to have a major impact on Victoria Crowe. She talks of 'the enormity of the sky, the ever-present wind, long winters, and hills bitten into with snow and ice, and the long light of summer days and nights.'

How, as an artist, was she to put that to use? Characteristically, she stood back from it for a while, watching and absorbing it. Eventually a time came during her children's early years (her son Ben was born in 1973 and her daughter Gemma in 1976) when, conscious of a dearth within herself of inventive energy, she turned to the strange new landscape and began to record it.

Her approach to the landscape was more than a mere prosaic investigative exercise. Filled with that spirit of place which means so much to her, the pictures resulting from her quest in themselves make up an important section of her oeuvre. They mark also a note-worthy stage in her development as an artist. Increasingly, she became fascinated by the extent to which the look of a landscape arises from what goes on in it and her pictures began to include signs of the animal and human life which contribute so much to its form and texture. First, footprints in the snow crop up in one painting (p.26); in another, a distant figure appears in the shape of a tiny silhouette – at first glance seeming hardly more than a scale indicator but soon recognisable, to those who have ever seen her, as the unmistakeable

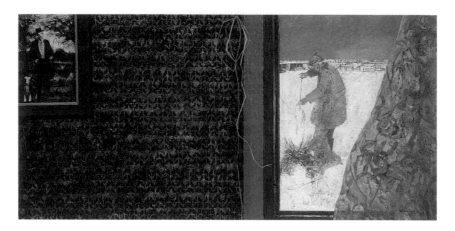

form of Jenny Armstrong traversing the inhospitable terrain with a loping stride. This distant shape, at once impersonal cypher and specific personage, sparks a tension that shimmers across the picture's vast landscape, creating an atmosphere of grandeur tinged with menace.

This painting, *Large Tree Group* (p.27), gives us our first, though far-off glimpse of the shepherd. Subsequent pictures have a different focus as the artist moved from the study of what she has called 'generalised landscape' to the depiction of more specific areas nearer to Monks Cottage. She painted not only the fields and fences, the marshes and nearby burns, but also the livestock. She lists among her subjects the flock feeding in the turnip fields, the Bantams, the hen-house and the woodshed and the dogs accompanying Jenny to feed

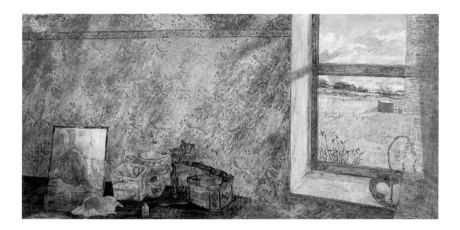

That Time of Year
Again, 1987–8
Oil on board
60.9 × 121.9cm,
24 × 48in
Collection of the artist

the sheep. When Victoria too began to accompany Jenny on her rounds she soon found herself with a store of memory-images of the older woman at work, together with an ever increasing knowledge of country life and habits. She recalls that:

> *seeing the landscape through Jenny's eyes, the tracks of weasel and of fox around the distant hen-house were not just visually interesting, but threatening and unwelcome marks from intruders* (p.24). *Sandy hollows – scars of long-past quarrying – and the dip in the field along by the drystone dyke, which were to me visual punctuations to the painted landscape were, for Jenny, exactly the places to go in a blizzard when looking for lost sheep* (p.29).

With the artist's growing understanding of her friend's way of life, the realities of its harshness and rewards were borne in upon her and the

pictures began to centre on the figure of Jenny, with the result that the gaunt woods and bitterly cold, snow-covered fields take on a new resonance.

In her younger days, during the late 1920s and the 1930s, Jenny Armstrong, working with three dogs, was used to herding over an area of 1200 acres around Fairliehope and about the same acreage over the difficult gully-crossed terrain on Kittleyknowe and South Mains. This could involve the lifting and carrying of sheep weighing as much as sixty kilos, or more if the weather was wet – something no conscientious shepherd of the old school would shirk.

Though light in comparison with what she had been used to in her younger days, the workload Jenny Armstrong now had to shoulder was nevertheless substantial. What is more, her little flock, had a habit of increasing. She found it hard to turn away any ailing, newcomer brought in for her attention. 'There's aye room for anither yin', seemed to be her motto. Caring for the sheep involved many skills, one of which was the construction and maintenance of fences – a craft she had long-since mastered. The purchase of conventional fencing materials was beyond her budget but she made up for a lack of funds by an abundance of ingenuity backed up by a lifetime's habit of hoarding any scrap material with potential.

Though at times they could appear to have been devised in a spirit of playful inventiveness, her fences were, nonetheless, capable of withstanding the assault of wind, weather and livestock – proof

indeed of her skill as a fence-builder. Victoria recalls an occasion when she and her husband were interrupted by Jenny in their own shaky attempt to construct a garden fence. Swooping down upon them and crying 'stand back!', she swung the mell and with a single blow, drove the recalcitrant stob well and truly into the ground.

In the elaborate new fences, sometimes coolly classical, sometimes playfully exuberant, the inventive idiosyncrasy of a genuine artist-craftsman can be detected. And Jenny's creative imagination

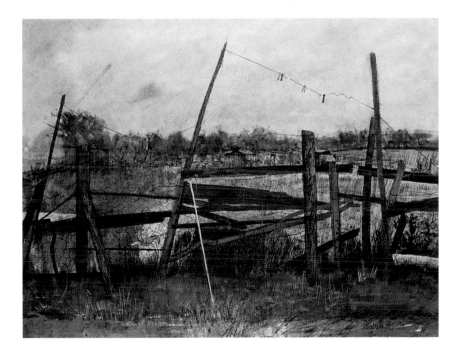

Fence to Keep the
Ram in, 1977
*Watercolour with ink
on paper, 55.8 × 76.2cm,
22 × 30in
Stirling Smith Art
Gallery and Museum*

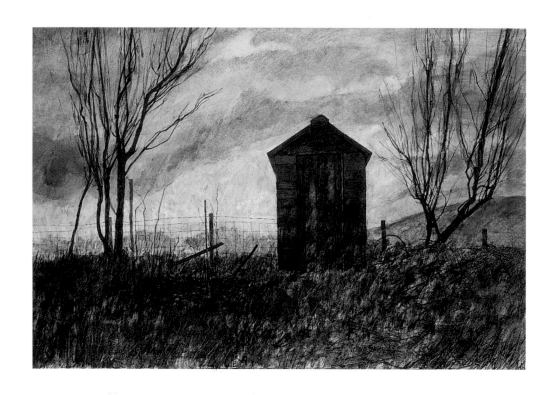

The Last Remaining Shed, 1972
Watercolour and ink on paper
48.8 × 35.5cm, 19.2 × 14in
Private collection

found another outlet: her observant eye was quick to notice, in the shape of a twig or stone or other product of nature, the character of some creature of the wild familiar to her. She would then create its vivid likeness with a few deft changes to the original material. This was done with complete lack of pretension and purely for her own amusement and delight which she was happy to share with Victoria who responded with appreciative enthusiasm. Once alerted to their existence, she continued to come across Jenny's 'artworks' in the form of half-jokey arrangements of found objects placed in unusual corners of outbuildings or perched on sections of fences and walls.

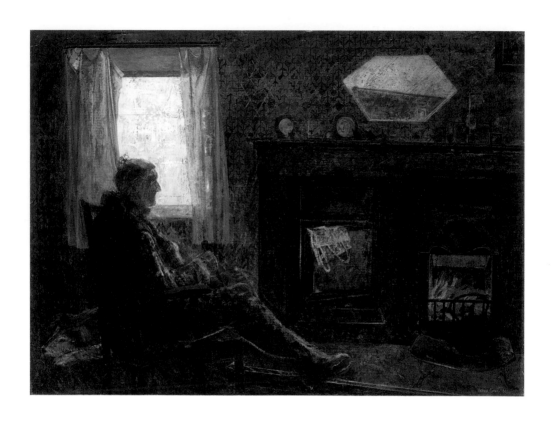

Winter Interior, 1981
Oil on board
91.4 × 120cm, 36 × 48in
Collection of the artist

JENNY, WHOSE ENERGY HAD SEEMED seemed boundless, was gradually becoming less physically able. By the late 1970s, though still much occupied with her sheep and chickens, she spent a large part of her day indoors where she liked to have Victoria's company as she sat by the fire. Then, in the old Scots vernacular of the Borders so natural to her, Jenny would recount stories of her past life and of local traditions. Here was an opportunity for the artist to draw the room and its owner from whom until now she had been unwilling to request a portrait sitting, sensing that Jenny would treat the notion of herself in the role of model as absurd, inappropriate, perhaps even embarrassing. But in the atmosphere of quiet companionship, no objections were raised. The two pictures which can most nearly be classed as conventional portraits (frontispiece and opposite) date from this period.

The time spent within the house opened up for the artist a range of new pictorial ideas that she has gone on to investigate and which continue to inform her work today. Struck by the contrast between the warm security of the shepherd's room and the harsh reality of the world beyond, she embarked on a series of pictures exploring this contrast and the tension it generates – a tension heightened by placing the figure looking out from within the room to some distant view not always visible to us.

The suggestion of threat latent in *Looking Out, First Light* (p.40),

39

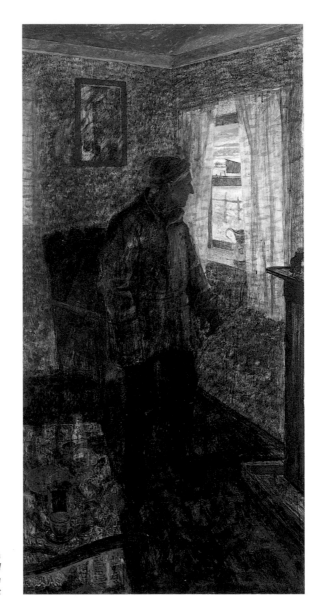

Looking Out, First Light, 1981
Oil on board
121.9 × 60.9cm, 48 × 24in
Collection of the artist

could be thought to involve a reference to weather. Victoria, as a fully integrated countrywoman, was constantly aware of the overwhelming significance and impact of the weather on the organisation of daily life for herself and the people around her. The picture, *Shepherd's Warning*, captures a moment seen from a window in her own home. *Snowshowers are Expected on Northern Hills*, on the other hand, while pinpointing one crucial moment in the day's routine pays tribute to Jenny's wireless set and reminds us of its importance among her many possessions.

Important in the day's routine as the weather forecast might be, it was not always heeded by Jenny who, despite increasing frailty, was still occasionally to be seen working out of doors whatever the weather. Exploiting the 'looking out' theme, the artist produced some of her most powerful work by making use of doorways or windows seen from within, to frame the figure of Jenny busy outside (p.30). This idea was continued in pictures where glimpses of the outside world are seen, not only through windows or doorways, but in occasional mirror-reflections within the room. The artist noticed that in these mirror-images the landscape-view became more telling by virtue of its isolation and unexpected juxtaposition with household objects.

She has since gone on to develop a complex iconography where the use of reflected images compounds ambiguities in time as well as space (p.48).

Landscape through
Drawn Curtains, 1982
*Watercolour and ink on
paper, 74.8 × 54.9cm,
29.5 × 21.5in
Private collection*

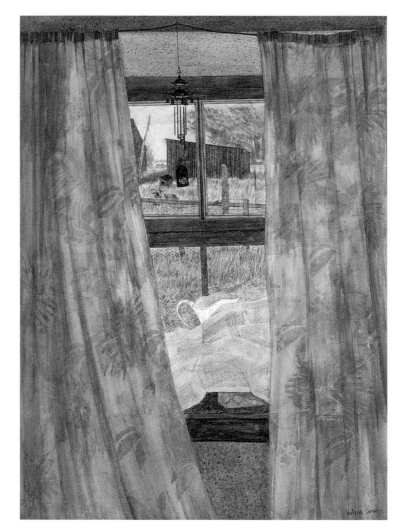

AS JENNY'S HEALTH DETERIORATED, SHE began to spend most of her time indoors and so, gradually, the pictures too, 'came in'. Monks Cottage was a two-roomed dwelling and Victoria Crowe found herself increasingly intrigued by the room where she sat with Jenny. This, the main living area of the house, was known as 'the room', and was used for a variety of purposes. Its principal feature was an iron range fuelled by gathered sticks and by logs and coal. Supplying warmth, hot water and cooking facilities which included an oven and hinged trivets to hold pot or kettle over the flames, it could also be used as a drying place for washing, and provided a lamb nursing area, as well as warm storage for kindlers.

The artist loved the quality of light within the room. She talks of 'the dim, firelit interior and the cold shifting snow-light through the thin curtains'. This atmospheric light had, for her, an almost palpable density which seemed to invest everyday articles with the mystery of sacred objects. But her attention was captured, above all, by the vast conglomeration of diverse items covering every surface. She noticed that the story of a life was discernible within this accumulated bric-à-brac in all its random incongruity. The picture *Airspun Powder and Baler Twine* pays affectionate tribute to the many and diverse strands interwoven through Jenny's personality and way of life. (Airspun was a popular brand of face-powder manufactured by Coty.)

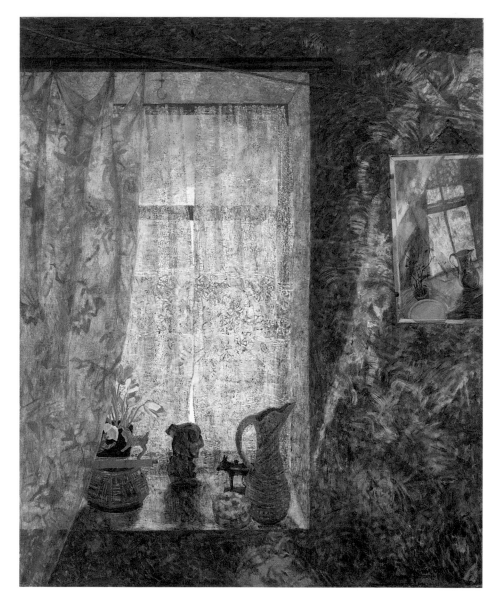

Private View with
Plastic Tulips, 1987
Oil on board
106.6 × 86.3cm,
42 × 34in
Collection of the artist

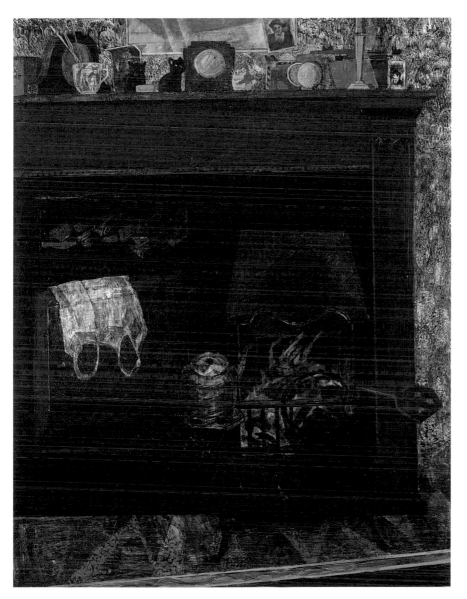

Range and Semmit,
1982
Oil on board
91.4 × 71.1cm, 36 × 28in
Collection Tanya
Westinghouse

Last Portrait of Jenny
Armstrong, 1986-7
Oil on board
117.6 × 91.4cm, 48 × 36in
Private collection

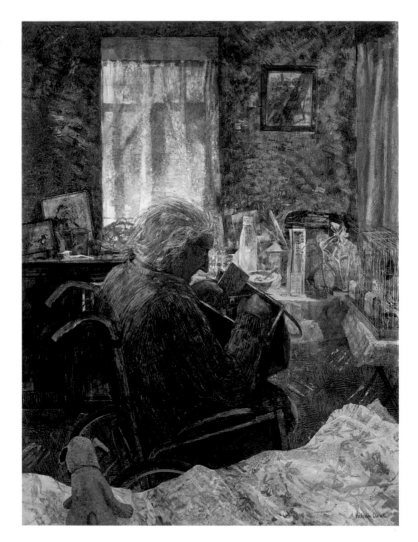

AS JENNY APPROACHED HER EIGHTIES the harsh reality of a lifetime out on the hills was beginning to take its toll. She required a double amputation and spent a year in hospital. The picture *No-one at Home* commemorates this period of her life, and a momentary sensation of vivid loss experienced by the artist one day during the early months of the shepherd's absence. Walking past Monks Cottage, her eye was caught by the unexpected deep red paint applied to the room's familiar window-frame by Jenny, prior to her departure. Perhaps it was this farewell gesture that triggered a sudden acute awareness of the void behind the glass – a feeling of emptiness reinforced by the inanimate presence of a group of little figurines from Jenny's collection of toys and ornaments.

Monks Cottage was not empty for much more than a year. Jenny was determined to come home, and her determination soon over ruled all counsel from her medical advisers. She returned in a wheelchair to the room, with its lifetime's clutter and open range, which now had to function as bedroom, living room and kitchen. The remaining sheep were to be given up. Even her long-time companion, the border collie, Laddie, had to find a new home and was taken into the care of a good friend. But drawing on the courage and determination which stamped her character, Jenny triumphed over all setbacks and refused to let her life become a tragedy.

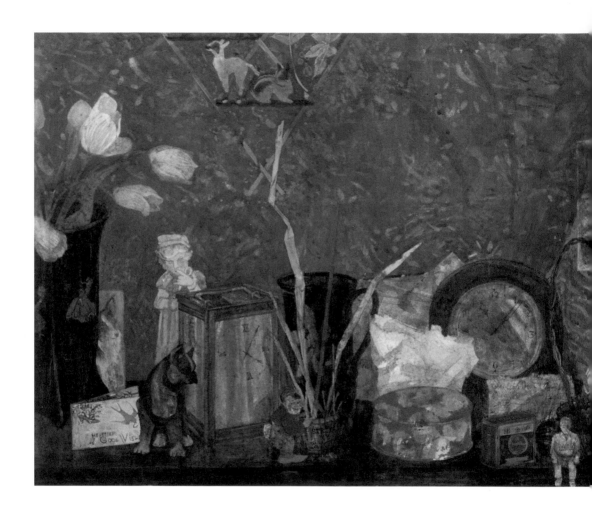

Future Remembered, 1988
Watercolour on paper
36.7 × 93.9cm, 14.5 × 37in
Private collection

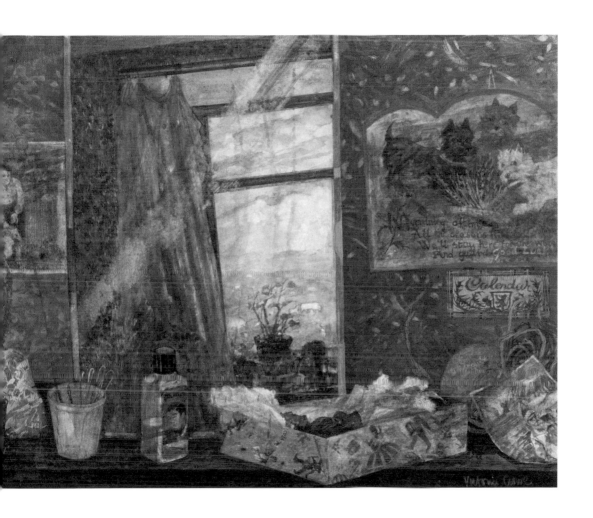

For years the room had been Victoria Crowe's inspiration. She speaks of 'its contents and possibilities revealing themselves slowly as Jenny and I sat and talked'. Since for her, source material for a picture comes from memory, observation and countless sketches, the recent changes at Monks Cottage were soon scrutinised in drawings, noted in sketchbooks and stored in her mind's eye as part of the continuing production of what had become a kind of visual diary – now revivified by Jenny's return.

Messages, one of the pictures from this period, shows the room, with its familiar trappings now slightly cramped by the addition of Jenny's bed. The title echoes Jenny's voice and reflects Victoria's pleasure at hearing the familiar Scots usage. The picture pays tribute to the milkman who helped Jenny by carrying her milk into the room, and occasionally leaving some item of general shopping, while seeing to her fire. Jenny's 'thank-you' was the apple put out for him each morning on top of the dresser. Supported in this way by a network of friends, family, local tradesmen and neighbours, Jenny's life went on in the relative peace and comfort of her home's familiar surroundings.

In *Messages*, as in the other oil paintings of the room, detailed observation gives way to a broader statement expressing the mood and atmosphere of the place. This can happen in response to differing light sources, whether from sun, firelight, or snow reflection. A favourite theme, light, itself sometimes becomes the pictures' subject.

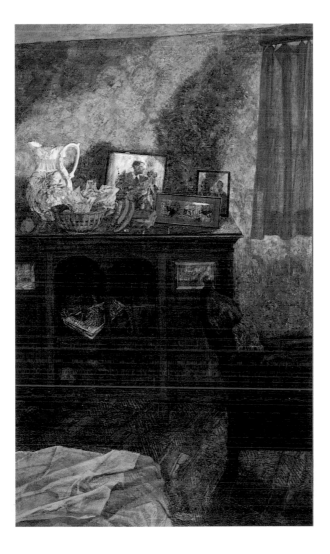

Messages, *late 1980s*
Oil on board
121.1 × 66cm, 48 × 26in
Collection John Blyde

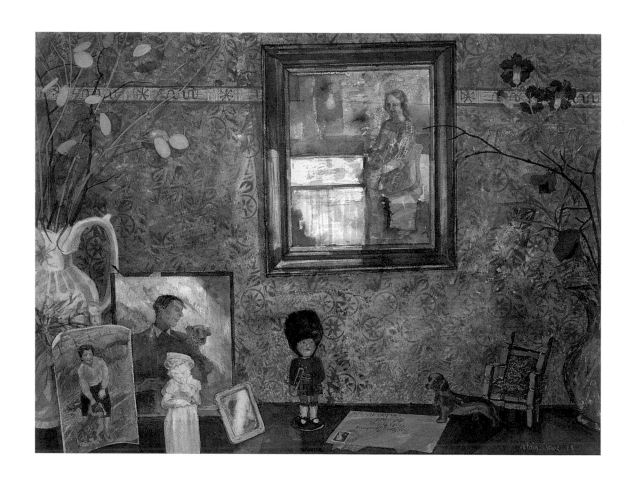

Celebration for Margaret, the Fraser Boy and all the Rest, 1984
Watercolour and acrylic on paper, 54.5 × 73.6cm, 21.5 × 29in
Collection of the artist

Victoria Crowe has spoken about how 'the light in that room, whether from within or without, silhouetted, encompassed, emphasised, obscured, enfolded, animated or revealed the objects, surfaces and inhabitants of that room'. This ambitious objective is achieved in three monochrome studies done in charcoal and chalk, originally undertaken simply as tonal investigations for larger oil paintings. Glowing with light, they are among the most complex and striking pictures to emerge from her prolonged study of the room.

Paying her usual visit to Monks Cottage one day, Victoria found Jenny slumped in her wheelchair following a stroke. She was taken to hospital where she survived for only four days. Jenny Armstrong died on 20 November 1985. She was eighty-two years old.

Victoria Crowe wanted to have a record, for her own reference, of the room as it was. The black and white photographs taken for this purpose were deeply depressing. They bore no relation to the sense of place she had been painting for so long. Though occasionally able to serve as an *aide-mémoire* for some factual detail, they could never be made use of in any creative way. Thereafter, she continued to paint that interior, relying on what has always been her primary source: memory and imagination playing upon acute observation of the physical world. The grand celebratory *Last Portrait of Jenny Armstrong* (p.46) was painted from a memory triggered by one insubstantial visual note in the artist's sketchbook. During the painting of this picture, as she recalls, the light, the atmosphere and all the individual

53

elements of the room, so long observed and distilled through memory, seemed to come together, allowing the dominant figure of Jenny Armstrong to emerge 'as if the room painted itself around her.'

The theme of Jenny Armstrong and her cottage have remained a potent source of inspiration in Victoria Crowe's artistic consciousness. Five years after Jenny's death she could say (remembering the room), 'I have a freedom now to select from all the images of that interior, to make the juxtaposition more telling and to let the sunlight fall where I will.'

I am grateful to Glyn Thompson of Coty Customer Services, and the Blackface Sheep Breeders' Association. MT

A RECENT PAST

VICTORIA CROWE

ONE OF THE REAL PLEASURES OF GETTING THE WORK together for this exhibition has been the opportunity to see the threads of ideas that began then and which continue into my present work. I realise that the practice of observing, over a long time, of recording and remembering, which I learned then, have provided me with the ways of working which I use today. That period was a time of information gathering, of personal discovery and growth – a seedbed of ideas – an apprenticeship in a way of distilling the objective into the significantly personal. I am surprised at how much, in terms of compositional devices and structure, notions of time and sequence, juxtaposition and memory which I am concerned with today are there – albeit sometimes germinal – in the work from the 70s and 80s of Kittleyknowe and Jenny Armstrong's way of life.

The paintings and drawings recording Jenny and the surrounding landscape remain very personal and of great value to me. It was a period in my life when I was drawing and researching much of what was new to me. I wanted to respond to the environment that I found myself in, and to gradually make some sense of it in pictorial terms.

The landscape I began working from at Kittleyknowe was an ever present, ever changing focus – huge open horizons of moorlands and distant hills with none of the shelter belts and gardens which are there now. Part of this visually rich environment was the day to day presence of Jenny, our shepherd neighbour going about her work.

During the early 70s, there was for me, a gradual unfolding of ideas, a resolution of images and a storing of information through constant looking and drawing. Hand in hand with that pictorial knowledge of the landscape and its occupants came a friendship and the appreciation of Jenny's way of life which was rich in meaning, simple and harmonious. I am not attempting to idealise her life; she had always been used to hard work and few creature comforts, but she had a fundamental and natural sense of her part within the greater whole.

Over those fifteen years shared with Jenny at Kittleyknowe, what began as a simple desire to record and understand a new environment, became a visual diary that also explored wider implications. The subject-matter of hillside and field, fence and hen-house, figure, tree group and interior, occupied me during those years. From direct observation of Jenny's life and her daily round of work, came a concern for surface and texture: such as scrubby reeds against frosted ground, stained and patterned wallpaper against pitted mirror edge, thin curtain fabric filtering light and the shed's blistered and flaking paint layers and wrinkled bitumen.

I found compositional possibilities in the isolation of one element within the whole: animals gathered into a corner behind irregular wood and wire fences, Jenny's profile, back-lit by a small window within the context of a shadowy interior, or a patch of fugitive colour on a hen-house door, made suddenly vibrant by the snowfall which had obliterated the hen run. I was interested in the way context changed the meaning of objects. The familiar landscape reflected in Jenny's mirror, or seen with startling clarity, as though through the wrong end of a telescope, isolated by a window or doorway became powerful within the setting of the room. *Family Circle* biscuit tins vied with evocative, iconic images such as favourite photographs, baler twine, *Brilliantine* and *Farmyard Friends'* calendars. Incongruous arrangements and juxtapositions, while fascinating in themselves, also provided a further layer of meaning which referred to different aspects of Jenny's life.

The later paintings of the room, where light from the landscape asserts its dominance, are overlaid with references of memory and time. The painted interiors are, to me, parallel experiences to being with Jenny in that room – its contents and possibilities revealing themselves slowly. The paintings and the charcoal pieces were a resolution not only of my drawing and looking, but also of Jenny's own story, which she shared with me. Watching Jenny at work and listening to her at home, had made me think of our relationship to the land, our impermanence *vis à vis* the enduring landscape and the

rhythms of nature and season. I can see that I used my drawings and paintings to examine these questions of value and reality together with our own function and purpose. By virtue of its very isolation Kittleyknowe focused these concerns.

Looking back to this recent past, there seemed to me a slowing down of time, a chance to observe and reflect and to experience life unfolding almost in the way Jenny did, with an ease which worked with nature and the seasons as part of the continuum of time.

POSTSCRIPT

I am delighted to see *A Shepherd's Life*, revisited at The Fleming Collection in London.

The legacy of the Jenny paintings, and my experience of the landscape at that time, has continued to inform and feed my work over the intervening years, albeit in different forms. Since the original exhibition in 2000, Jenny has found her rightful place in *The Biographical Dictionary of Scottish Women*.

Most recently, a tapestry was commissioned by the Duke of Buccleuch from the painting, *Two Views* (p.32). This was beautifully translated and woven at the Dovecot Studios in Edinburgh and is included for the first time in this exhibition. This has seen the fulfilment of a long-term ambition and is a fitting tribute to Jenny.

PHOTOGRAPHIC CREDITS